Skira**M**ini**ART**books

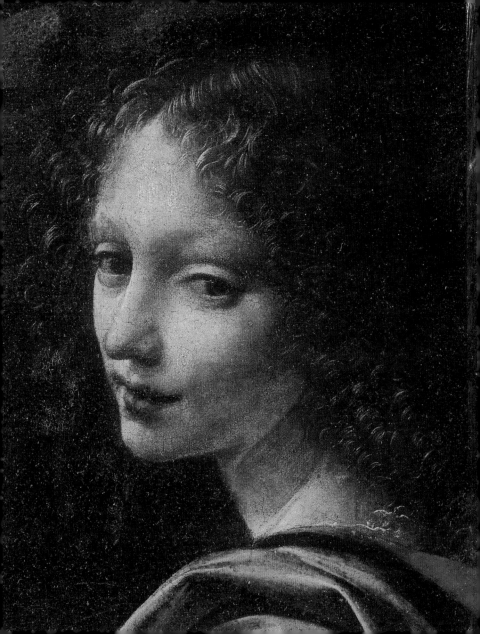

Lucia Aquino

LEONARDO DA VINCI

front cover
Portrait of Monna Lisa
del Giocondo (*Mona Lisa*)
(detail), 1503-04 and 1510-15
Oil on wood, 77 x 53 cm
Musée du Louvre, Paris

.

Skira editore
SkiraMiniARTbooks

Editor
Eileen Romano

Design
Marcello Francone

Editorial Coordination
Giovanna Rocchi

Editing
Maria Conconi

Layout
Anna Cattaneo

Iconographical Research
Alice Spadacini

Translation
Christopher "Shanti" Evans
for Language Consulting
Congressi, Milan

First published in Italy in 2008
by Skira Editore S.p.A.
Palazzo Casati Stampa
via Torino 61
20123 Milano
Italy

www.skira.net

Printed and bound in Italy.
First edition

ISBN 978-88-6130-737-7

Distributed in the US and Canada
through Rizzoli International
Publications by Random House,
300 Park Avenue South,
New York, NY 10010.
Distributed elsewhere in the world
by Thames and Hudson Ltd.,
181a High Holborn, London
WC1V 7QX, United Kingdom.

facing title page
The Virgin with the Infant Saint
John adoring the Infant Christ
accompanied by an Angel
(*The Virgin of the Rocks*)
(detail), 1483-86
Oil on wood, 199 x 122 cm
Musée du Louvre, Paris

on page 80
Portrait of Monna Lisa
del Giocondo (*Mona Lisa*)
(detail), 1503-04 and 1510-15
Oil on wood, 77 x 53 cm
Musée du Louvre, Paris

Archivio Skira
© Foto Archivio Scala, Firenze,
2008
© Foto Musei Vaticani

Works owned by the
Soprintendenza are published
by permission of the Ministero
per i Beni e le Attività Culturali

The publisher is at the disposal
of the entitled parties as regards
all unidentified iconographic
and literary sources.

Contents

Leonardo da Vinci

I t was from his grandfather Antonio, in whose home the youngster spent his early childhood, that the world first received the news of Leonardo's birth. "A grandson, the son of my own son ser Piero, was born on April 15 [1452], a Saturday, at three hours in the night [corresponding to our 22:30]." Leonardo was the illegitimate son of ser Piero, a notary and a member of a rich family of landowners in the Empoli region, and Caterina, a peasant girl who was later to marry a certain "Achattabriga di Piero del Vacca da Vinci". We do not know for sure when Leonardo moved to Florence; he may have followed his father, who was already there in 1464, the year in which his first wife, Albiera di Giovanni Amadori, died and was buried in the city.

The earliest documentary record to have come down to us is that of the annual payment, made in the year 1472, to the Compagnia di San Luca, the guild of Florentine painters. Certainly by this date the twenty-year-old Leonardo was a painter, who had already completed his training, in the strict sense of the word, in Verrocchio's versatile workshop, but two documents from the spring and summer of 1476 tell us that he was still collaborating with this artist: "Lionardo di ser Piero da Vinci is with Andrea del Verrochio." Giorgio Vasari (the biographer from Arezzo who wrote the *Lives of the Most Eminent Painters, Sculptors, and Architects*) tells how ser Piero, realizing his son's strong aptitude for drawing, apprenticed him to his good friend Verrocchio. Among those who passed through this workshop between the end of the sixties and the early seventies were artists of the calibre of Botticelli, Ghirlandaio and Perugino. Verrocchio's many talents extended beyond the regular disciplines of painting, sculpture and drawing to the fields of carpentry, casting and mechanics in general. The basis of the master's teaching method was drawing, a technique common to all the arts, and a special

type was practised in Verrocchio's workshop: brush drawing "in black and white" on linen cloth. Drawing, therefore, as the fundamental underpinning of art, drawing as representation of movement and nature: it is no coincidence that Leonardo's first dated work is a sketch in pen and bistre (now in the Gabinetto dei Disegni e delle Stampe of the Uffizi and dated 5 August 1473), with a hilly landscape on the recto of the folio. It cannot have taken long for Verrocchio to become aware of his pupil's bent for landscape, if critics are correct in ascribing to Leonardo several views and naturalistic elements in pictures that were painted in his workshop (*The Virgin and Child with Two Angels*, National Gallery, London; two images of the *Madonna and Child* now in the Gemäldegalerie in Berlin and the fish and little dog which appear in the *Tobias and the Angel* in the National Gallery, London).

Madonna and Child (Madonna with the Carnation) (detail), *circa* 1470
Oil on wood, 62 x 47.5 cm
Alte Pinakothek, Munich

The *Madonna and Child with a Pomegranate,* now in the National Gallery of Art in Washington, is Leonardo's earliest known work. It clearly reflects its origin in Verrocchio's circle, and in the past has been attributed either to Verrocchio himself or to his faithful pupil Lorenzo di Credi. But Leonardo was the only member of the workshop capable of such fineness of execution, using a delicate and precise touch, and of giving such transparency to the flesh tones and clothing; this is also true of the handling of the drapery, which shows close parallels with the studies on linen mentioned above. The lack of correspondence between the figures, the blank expressions on the faces and other uncertainties indicate the hand of a still immature painter (the painting dates from around 1469). But the head of the Virgin emerging from a dark ground and the landscape are, in embryonic form, characteristics that were to be-

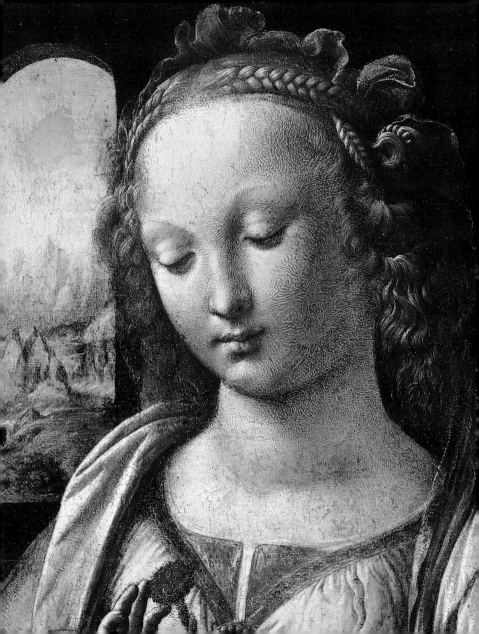

come typical of Leonardo's work. The same typological features are found in the so-called *Madonna with the Carnation* (Alte Pinakothek, Munich), which must have been painted immediately after the picture in Washington and which also strongly reflects the Verrocchiesque milieu, as is clear from the yellow drapery in the foreground. Here the young artist experiments with the technique of oil, in an attempt to compete with the Flemish painting whose reputation had reached as far as Florence, and the image is a highly effective one as Leonardo succeeds in creating a translucent surface and imparting mutability to the light.

The aura of mystery in which Leonardo's life is steeped derives in part from the fact that many of the works he created have been lost. Traces of some of these survive in studies in his own hand or in paintings attributed to his followers, while all that is left of others is the reference to them in the sources.

We can get an idea of Leonardo's approach to the portrait, around the middle of the 1470s, from the so-called *Ginevra de' Benci* (National Gallery of Art, Washington), where the Verrocchiesque type of the *Lady with Primroses*, now in the Museo del Bargello in Florence, is skilfully blended with the Flemish technique of painting. If we accept the hypothesis that the portrait was a commission from the Venetian ambassador Bernardo Bembo, "platonically in love" with Ginevra, then it reflects the ambience of the Florence in which Leonardo found himself operating. A city at the height of the Laurentian era, steeped in an atmosphere that was at once Humanistic and aristocratic, where on the death of his father Piero in 1469, Lorenzo de' Medici, better known as the Magnificent, had placed himself at the head of the city's government. He quickly became a client and patron of artists: he was the owner of

the famous "garden of San Marco", a sort of school for young painters and sculptors that, according to Vasari and the anonymous author of the Magliabechiano manuscript, was frequented by Leonardo as well.

On 10 January 1478, a few months prior to the conspiracy of the Pazzi in which Lorenzo's brother Giuliano was assassinated, the Priors of the city of Florence, in the kind of formal and solemn act typical of the *Deliberazioni dei Signori e Collegi* (resolutions made by members of the ruling council and the colleges), assigned Leonardo the task of painting the altarpiece of the chapel in the Palazzo della Signoria dedicated to St. Bernard: the subject of the painting was not specified. The Florentine government wanted to replace the existing altarpiece, painted in 1355 by Bernardo Daddi, now old, outdated and too remote from the fashion of the time, with one that would reflect contemporary taste. Despite the fact that the commission was never fulfilled, it is important because it represents a remarkable sign of trust in an artist just starting out on his career, a young talent who was yet to show what he was capable of.

Following pages
The Annunciation
(detail), *circa* 1472-75
Oil and tempera on wood,
98 x 217 cm
Galleria degli Uffizi,
Florence

And it was while Leonardo was still under Verrocchio's influence that he conceived the *Annunciation*, transferred to the Uffizi in 1867 from a wall of the sacristy of the Olivetan church of San Bartolomeo. In addition to the frequently made comparison of the marble base of the lectern with the tomb of Giovanni and Piero de' Medici, executed by Verrocchio around the same time in San Lorenzo, this influence is evident in the drapery of the figures, once again connected with those studies made with the brush on linen. The handling of the work's perspective, often criticized, appears in more positive light if the panel is observed from a particular point of view: from the right and

11

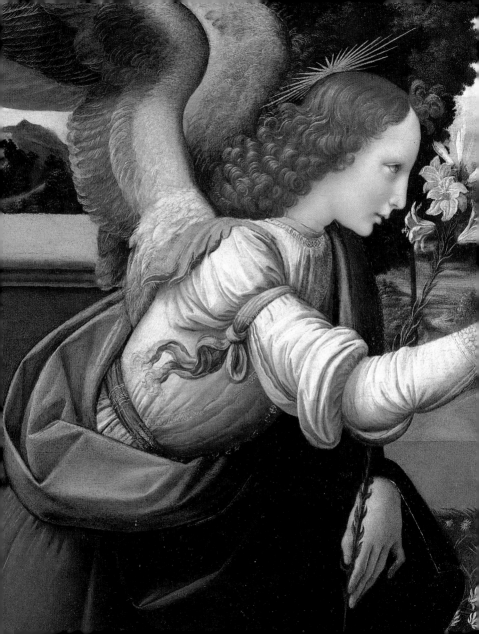

slightly from below. The inconsistencies of perspective are then revealed as experiments with anamorphosis, which were conducted by Leonardo at various stages in his artistic career.

Verrocchio's *Baptism of Christ*, now in the Uffizi but recorded by the documents in the church of San Salvi in Florence, is the only painting among those examined so far that is mentioned by the 16th-century sources. Everyone knows Vasari's story of how after seeing the angel painted by Leonardo his master decided to give up practising this art and devote himself exclusively to sculpture. The picture has often been taken as an emblem of the team work typical of an artist's studio in the Renaissance, but more recent critics have pointed out that Leonardo's intervention should be seen not as the first collaboration of a young artist in his master's workshop, but as an effort to improve the fortunes of a not very successful painting. The *Baptism* may have been commenced by the master and his pupils (Botticelli's name has even been put forward for the angel next to the one painted by Leonardo) several years earlier and finished at the end of the seventies; by that time Leonardo had an artistic personality all of his own. The difference in the quality of the brushwork is evident to a cursory glance. The foreshortened view of the beautiful and brilliantly handled angel, represented with his back to us but the head turned to one side and looking obliquely upwards at Christ, is unique in the Florentine painting of the time for its mastery of anatomy, the human structure and space. The imitation of reality that Leonardo achieves in the landscape in the background can be taken as emblematic of his conception of painting: it is an open window, through which the eye is presented with the image of a world perceived at such

The Virgin with the Infant Saint John adoring the Infant Christ accompanied by an Angel
(*The Virgin of the Rocks*)
(detail), 1483-86
Oil on wood, 199 x 122 cm
Musée du Louvre, Paris

14

a level of simulation that it could be taken for a real view. The Baptist's body, on the other hand, is linked to the circle of Pollaiuolo, while the hands of God the Father and the palm tree appear so archaic and of such poor quality that there is no question of attributing them to either Verrocchio or Botticelli.

Before leaving Florence for Milan Leonardo provided a demonstration of the maturity his art had attained in two masterpieces in monochrome, even though they were left unfinished: the *Saint Jerome* (Pinacoteca Vaticana, Vatican City) and the *Adoration of the Magi* (Galleria degli Uffizi, Florence), commissioned in the March of 1481 by the Augustinian canons for the high altar of San Donato at Scopeto near Florence. It is precisely the incomplete character of the two works that furnishes us with precious information about their genesis. The former is an example of the grasp of human anatomy and its relationship with the surrounding space that he had achieved. The *Adoration of the Magi* is a summation of the great progress made by the artist in his understanding of nature and human emotions. In the background, where an event preceding the Epiphany seems to be represented, we see on the right a clash of unsaddled armed men and rearing horses; on the flights of steps on the left, men working on the reconstruction of a ruined building, with new parts standing alongside dilapidated structures; and on the broken arch small shrubs like the ones sometimes seen on constructions where for some reason work has been interrupted and nature has had enough time to get a grip on them again. Another work from these years is the small *Benois Madonna*, which was irreverently described by the critic Bernard Berenson (1916) as the portrait of a young woman with a bald forehead and toothless smile; but the number of copies in existence, all

traceable to the Florentine milieu, are an indication of the immediate popularity of the composition.

I t was probably in the month of September 1482 that Leonardo went to Milan to work for Ludovico il Moro; although the latter did not become duke until 1494, he had been the city's *de facto* ruler since 1480. Thanks to this man's ambition the Milanese court became one of the richest and liveliest in Italy, to the point where it rivalled Florence: a refined centre of Humanistic culture and a magnet for scientists, artists and men of letters, amongst whom it will suffice to mention the names of the architect Donato Bramante, the mathematician Luca Pacioli and the musician Franchino Gaffurio, perhaps portrayed by Leonardo in a work now in the Pinacoteca Ambrosiana.

According to the sources, Leonardo was sent to Milan by Lorenzo the Magnificent, along with Atalante Migliorotti, in the capacity of an expert on music. But a letter written by an amanuensis, addressed to Ludovico and perhaps never sent (it is included in the Codex Atlanticus) reveals that Leonardo hoped to carry out works of military engineering, civil architecture and, not least, painting and sculpture for the ruler of Milan. It was in this stimulating environment that Leonardo the theorist and man of science emerged.

As far as the works of painting executed in the Lombard capital are concerned, it was on 25 April 1483 that he received the commission, along with the brothers Ambrogio and Evangelista de' Predis, to paint the central panel of an imposing and variegated altarpiece to be placed in the chapel of the Concezione in the church of San Francesco Grande. The thorny question of why the subject represented in the *Virgin of the Rocks* in the Louvre, with which this first commission is generally iden-

tified, does not correspond to the one requested by the members of the confraternity of the Conception is still to be resolved. In the notarial contract, which is moreover highly detailed, it is expressly stated that the central panel of the complex structure was to be arched in shape and contain the Madonna and Child surrounded by a group of angels and two prophets, while the two panels at the sides were to be rectangular and depict four angels each, in the act of playing musical instruments and singing. The fact that later documents indicate Ludovico il Moro as the man who was able to persuade the members of the confraternity to increase the amount of recompense originally agreed on has led some to conclude that the duke may have played a direct part in the genesis of this painting, as well as in that of the version in London, which also undoubtedly came from the church of San Francesco Grande. A possible reconstruction of what happened, although a complicated one, has been put forward in connection with the theme of the Conception (Marani). In fact it was in Milan that Sixtus IV, a Franciscan pope, had sparked off a theological debate on the dogma of the Immaculate Conception in 1475 and had admitted the belief in 1477 (although it was not declared a revealed doctrine by the Church until 1854). Thus the interpretation that Leonardo offers of this creed in the *Virgin of the Rocks* may derive from the theological ideas of João Mendes de Silva, better known as Amadeus of Portugal, adviser and personal confessor of Sixtus IV as well as founder of Franciscan monasteries in Lombardy. The Blessed Amedeus had lived for almost fifteen years with the Franciscan monks in Milan, where he was protected by the duke at the time, Francesco Sforza. Hence it does not seem too abstruse a conjecture to suggest that Ludovico il Moro,

Head of Christ,
circa 1497 and later
Black chalk, red chalk
and pastel reworked
with charcoal and
tempera/bistre brushwork
on pale green paper,
40 x 32 cm
Pinacoteca di Brera, Milan

18

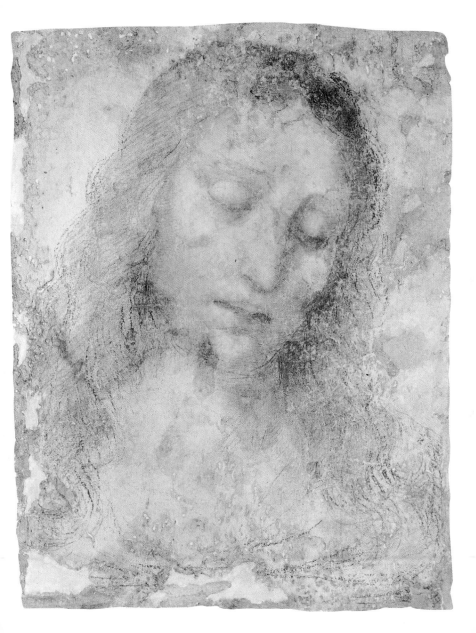

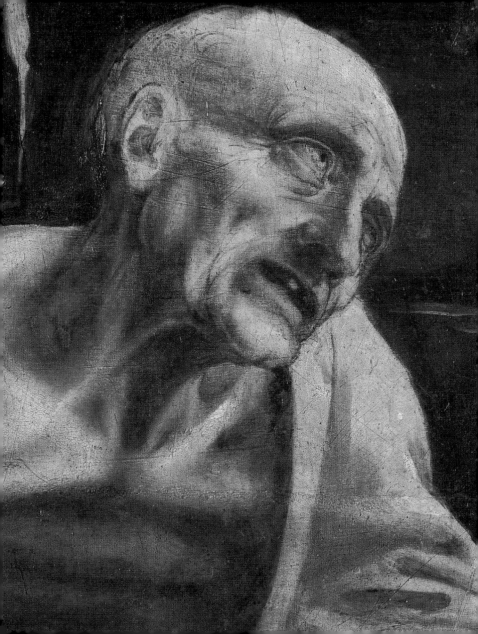

following in the footsteps of his predecessor, wished to commission from Leonardo a painting that would reflect the theology of Mendes de Silva. This would explain the divergences between what was stipulated in the contract of 1483 and what we see today in the painting in the Louvre, which may not have been brought to San Francesco Grande until later on, and then removed at an unknown date. Thus the picture painted by Leonardo for Ludovico il Moro would have been intended to occupy the place on the altar only temporarily, while the artist was preparing the version now in London and which he must have been working on up until 1506-08.

In Milan Leonardo also demonstrated his skills as an architect. His studies aimed at solving the problem of the lantern of Milan Cathedral, the drawings of which are preserved in the Codex Atlanticus and the Codex Trivulzianus, date from 1487-88. Manuscript B (Bibliothèque de l'Institut de France, Paris) is devoted to religious buildings on a central plan; in some of these sketches, and especially the ones of central-plan churches with a cross inscribed in a square, critics have recognized Bramantesque ideas.

In fact Donato Bramante had also been called on by Ludovico il Moro, in his capacity as court architect, to collaborate with Leonardo on the realization of some works in his residence, the Castello di Porta Giovia (later Castello Sforzesco). Two documents dating from 1489 and 1490 show that Leonardo was in debt to the confraternity of Santa Maria presso San Satiro, a building to whose reconstruction Bramante made a decisive contribution, but we cannot be sure of his direct involvement in the undertaking. It is more likely, however, that he did work with Bra-

mante on the architectural renovation of Santa Maria delle Grazie. On 21 June 1490 he went to Pavia with the Sienese architect Francesco di Giorgio Martini to inspect the construction of that city's cathedral.

Between 1488 and 1493 Leonardo had, among numerous other undertakings, designed the model for the equestrian statue of Francesco Sforza. This commission too came from Ludovico il Moro, who wanted to celebrate the dynasty through a campaign of propaganda, with the aim of adding lustre to his own image and legitimizing his rule (many people regarded him as a usurper, as he had seized power from the rightful duke, his nephew Gian Galeazzo Sforza). Leonardo's plan was to cast the sculpture in bronze using an experimental and revolutionary procedure: the model was to be placed upside down in a gigantic pit.

As the surviving drawings show, Leonardo had first imagined the sculpture as a rampant horse knocking down a foot soldier, and then as a horse trotting on a tall podium. The project was never carried out, but Leonardo's idea was for the "great horse" to have stood free in space; a type of sculpture that would have to wait another century and a half before being realized by Gian Lorenzo Bernini.

His interest in the anatomy of animals and men dates from the same years. At that time Leonardo commenced a book on the anatomy of the human figure, a subject that he was to go on investigating for the rest of his life. Even his caricatures can be linked to his anatomical studies, as variations on the theme of the human face. In the past this artistic speciality of Leonardo's was highly popular and has been widely reproduced. Also connected with the caricatures are the studies of physiognomy, in which the artist inverts the proportional relations of the face, allowing him to convey

precise characteristics and states of mind. An example of this is a large folio in the Royal Library at Windsor Castle with a drawing of *Five Grotesque Heads*.

As ducal engineer Leonardo tackled the problem of the regulation of waters in the city of Milan and on the summer estate of the dukes, the Sforzesca at Vigevano. For the artist the Sforza court was an ideal place to explore his varied interests and as a result he even became involved in the organization of festivals; one example was the "Festa del Paradiso" staged in 1490, in honour of Duchess Isabella of Aragon, bride of Gian Galeazzo Sforza, for whom he also designed a pavilion in the park of the Castello Sforzesco.

The portrait was another genre to which Leonardo devoted much attention in this period; in it he experimented with his theory of the "movements of the mind", the use of colour and the study of optical and perspective phenomena. We have already mentioned the presumed portrait of the musician Franchino Gaffurio, choirmaster of Milan Cathedral from 1484, who is represented apparently frozen at the moment just before or after the singing of the last note of a chant or a piece of music. Not to speak of the heights attained in the portrait of the *Lady with an Ermine*, now in the Czartoryski Muzeum of Cracow, who seems to come alive in the space: the rotation of the woman's body and the start made by the animal impart a circular movement to the surroundings. The sitter is generally identified as duke Ludovico il Moro's beautiful and refined mistress Cecilia Gallerani (to whose name the ermine, *gale* in Greek, alludes). In 1498 the portrait was shown by the woman herself to Isabella d'Este, so that the cultured marchesa of Mantua could compare Leonardo's mode of operation with that of Giovanni Bellini.

23

More simple in its construction is the *Portrait of a Lady* in the Louvre, incorrectly known as *La Belle Ferronnière*; it was the last example of this genre of painting executed by Leonardo during his first stay in Milan. The picture has also been attributed to Boltraffio, one of the artist's most talented Milanese followers, but critics are inclined to regard it as Leonardo's own work because of the marvellous device of the direction of the subject's gaze, which avoids meeting our own, obliging us to move our eyes continually in an attempt to encounter hers. This gives the portrait a three-dimensional appearance, almost as if it were a sculpture around which we can move.

Saint John the Baptist
(detail), *circa* 1508-13
Oil on wood, 69 x 57 cm
Musée du Louvre, Paris

And so we come to speak of the undertaking which can be considered the height of perfection in Milanese painting: the *Last Supper* in the refectory of the Dominican monastery of Santa Maria delle Grazie. The artist received a payment for this work, painted *a secco*, i.e. on dry plaster, in 1497 and since it is mentioned in Luca Pacioli's *De Divina proportione* of 1498, we can assume that Leonardo had completed it some time between these two dates. The impression produced by the *Last Supper* at first sight is that it breaks through the wall on which it is painted, as if it were a trompe l'oeil, and creates a nonexistent space. The recent restoration has made it possible to establish the technique used for its execution: one or two coats of tempera painted over two layers of preparation, an inner one that adhered to the rough plaster and a chalky one, i.e. with a base of calcium carbonate, to which the colours were applied. The experimental technique adopted, which has led to loss of the colour from various parts, allowed Leonardo to work more slowly than he would have had to do

if he had utilized the more usual one of *buon fresco*. This gave him the opportunity to make a series of changes and adjustments, as well as to finish off the clothes with highlights and impart an effect of transparency to the glassware on the tables, things that he could never have done if he had painted in fresco.

In the same years Leonardo worked on some rooms (including the "Saletta Negra") in the Castello Sforzesco, but the only one that survives today is the Sala delle Asse, on the ground floor of the square tower to the north. This room was decorated as if it were a canopy of trees like the ones used in the temporary structures created for festivities, but the ceiling was completely repainted at the beginning of the 20th century, and all that remains of Leonardo's invention are the fragments of monochrome painting on the walls with heaps of rocks that rise from the floor, twisting roots and small plants, amongst which we can recognize the common bulrush or cattail, *Typha latifolia*, an aquatic grass of which the artist was particularly fond and which also appears in a folio with a study for the kneeling Leda, in Rotterdam.

As far as Leonardo's private life in the Milanese period is concerned, we know from his own precise notes that Gian Giacomo Caprotti da Oreno, nicknamed Salai, "Devil", joined him there in 1491. Leonardo took great care of this boy, feeding and clothing him over the years, and what is most surprising is the patience that he always showed to this far from easy person, renowned for his bad behaviour. Which did not stop Leonardo from lending him money, loving him, preferring him over others and finally leaving him a substantial bequest in his will as a reward for "his good and loyal services". There are conflicting interpretations of just what nature those services may have been; some have concluded

that there was a homosexual relationship between the two men, partly as a consequence of the fact that one of the few documentary records of Leonardo's time in Florence is an accusation of sodomy. Whether this is true or not, what comes through is the impression of a good-natured man, willing to forgive, to pardon the faults and mistakes of others.

The year 1499 was an evil one for Ludovico il Moro. On 24 July the news reached Milan that King Louis XII of France had crossed the Alps and was laying siege with his army to the stronghold of Trezzo, one of Ludovico's possessions. On 19 August the French took Valenza. With Sforza's flight to Innsbruck Leonardo too left Milan, along with his friend Fra Luca Pacioli, and took refuge in Mantua, where the cultured Marchesa Isabella d'Este had been waiting for him for some time. Naturally the marchesa asked Leonardo to paint her portrait and the beautiful cartoon for the picture can be admired today in the Musée du Louvre in Paris, depicting the noblewoman in profile. Along the lines that form the sumptuous dress can be seen the tiny holes that would have been used to apply very fine charcoal powder to the panel as the basic outline of the painting.

Before returning to Florence, Leonardo spent a short period in Venice in 1500, during which time he was asked to draw up plans to defend the city from attack by the Turks. He was in Rome in March 1501, as is attested by a folio in the Codex Atlanticus that has a drawing of Hadrian's mausoleum (Castel Sant'Angelo) on the recto. His presence in the Eternal City should be seen in relation to the ties that he had established with Pope Alexander VI and his son Cesare Borgia, duke of Valentinois, whom Leonardo had probably already met in Milan, when the latter entered the city in the retinue of King Louis XII of

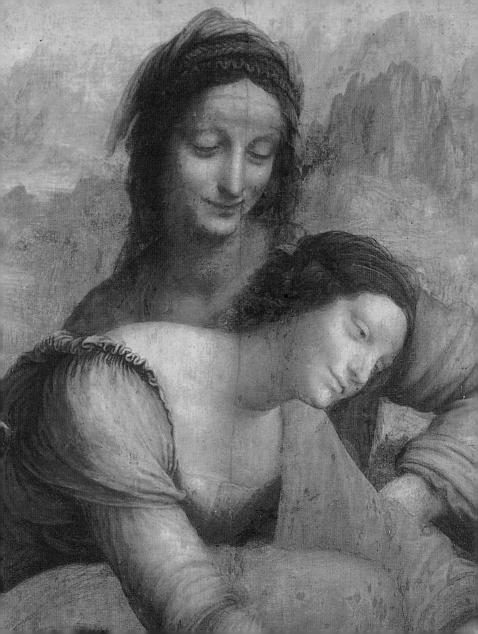

France. He undoubtedly visited Tivoli and the ruins of Hadrian's villa, and the extent to which the vestiges of ancient Rome stirred his curiosity can be inferred from the works of art he created following this visit.

The cartoon of *The Virgin and Child with Saint Anne and Saint John the Baptist*, now in the National Gallery in London, was conceived immediately after the *Last Supper*, although recent criticism has tended to assign a later date to its execution. It reflects the ideas that Leonardo had applied in the *Last Supper*, such as the monumental scale of the figures, the style and even the way of grouping the apostles. The cartoon is the most classicizing work of Leonardo's entire output, suggesting to some of the more acute critics that the grandeur of these figures was inspired by some classical sculpture. Leonardo continued to work on the theme of the *Saint Anne* once he had returned to Florence, where he was the guest, along with his entourage, of the Servites of the Santissima Annunziata, for whom he prepared a cartoon with this subject, now lost, that was much admired by his contemporaries. The artist would later (1510-13) return to the same theme in the painting now in the Louvre.

Virgin and Child with Saint Anne and a Lamb (detail), *circa* 1510-13
Oil on wood, 168 x 130 cm
Musée du Louvre, Paris

As a result of the disastrous political events that led to Ludovico's downfall, Leonardo now entered the service of Cesare Borgia, in the role of "military architect and general engineer". He was even granted a safe-conduct allowing him to move freely in the domains of the duke of Valentinois: in fact he went to Urbino, where he designed the chapel of the Perdono in the Ducal Palace, as well as to Pesaro, Rimini, Cesena and Cesenatico, where he paid a visit to the canal harbour, and finally to Piombino, where he was later to return to work for Jacopo Appiani on Machiavelli's recommendation in 1505.

29

By the time Leonardo went back to Florence many things had changed: Lorenzo had died, the Medici family had been sent into exile and a republic had been established. On 1 November 1502 Pier Soderini was elected gonfalonier for life, marking the beginning of a new era for the city. A decade of new commissions designed to create the image of a great patron, perhaps aimed at making the difficulties that the republic was going through owing to the war for the conquest of Pisa and above all the ever increasing financial demands of the king of France more bearable for the Florentine people. The most important commission received by Leonardo in Florence was for the decoration of one wall of the Sala del Maggior Consiglio (now the Salone dei Cinquecento) in Palazzo Vecchio; this was to depict an episode of Florence's war against Pisa, the *Battle of Anghiari*, fought on 29 June 1440 between the alliance made up of papal, Venetian and Florentine troops and the Milanese forces of Filippo Maria Visconti led by Niccolò Piccinino. At the same time Soderini had entrusted Michelangelo Buonarroti with the task of painting another wall of the same room with the *Battle of Cascina*, at which the Florentines under the command of the Englishman John Hawkwood had defeated the Pisans on 29 July 1364. The two greatest artists of the time, both exceptionally present in Florence in the same years, were to vie with one another on the walls of the room most emblematic for the Florentine people, the seat of their government. In October 1503 Leonardo was handed the keys of the Sala del Papa in Santa Maria Novella and other adjoining rooms so that he could use them to prepare the cartoon for the battle. And Leonardo must have worked briskly on the cartoon that winter, for in January the artist took delivery of the timber he needed and in February paper and canvas for the cartoon itself, along with an adjustable scaffold. On 4 May

the instructions, times and mode of payment for the undertaking were laid down in a resolution on the part of the *Signori e Collegi*. But by December of 1505 the process of transferring the cartoon onto the wall of the room was halted because the paint had begun to run as a result of the technique used, a clumsy attempt at encaustic, adopted in order to give the mural the mysterious depth, transparency and luminosity that oil painting had acquired thanks to Leonardo himself. The cartoon was lost soon after Leonardo's departure; according to Benvenuto Cellini, it was taken to the Sala del Papa in Santa Maria Novella: "And for the whole time they remained intact [he is also referring to Michelangelo's cartoon in Palazzo Medici] they served as a school for all the world."

Following pages
The Virgin and Child
with Saint Anne and Saint
John the Baptist
(detail), *circa* 1501(?)-05
Black chalk and touches
of white chalk on brownish
paper, 141.5 x 104.6 cm
National Gallery, London

Nothing of this enterprise seems to have survived, neither the picture painted by Leonardo, who went back to Milan to work for the French, nor Michelangelo's cartoon, which the artist had not even begun to transfer onto the wall before being summoned to Rome by Pope Julius II. We can get a pale idea of what Leonardo's creation must have looked like from the fine copy of it made by Rubens that is now in the Louvre, but this only reproduces the main scene of the battle. From the few surviving drawings, consisting of two heads in pencil for the central figures of the combat and the head of a warrior in profile, along with two or three more folios with skirmishes of horsemen, it is impossible to deduce the appearance of the picture as a whole.

I n his maturity, probably between 1501 and 1506, Leonardo devoted himself to the formulation of the so-called *Leda*, although he had been reflecting on the subject since the 1490s. The solu-

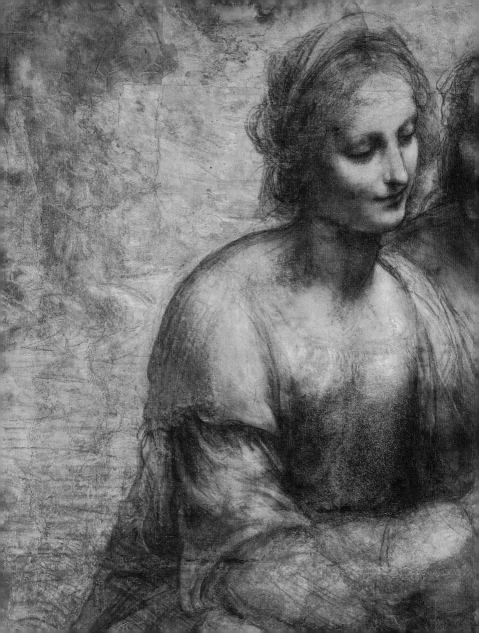

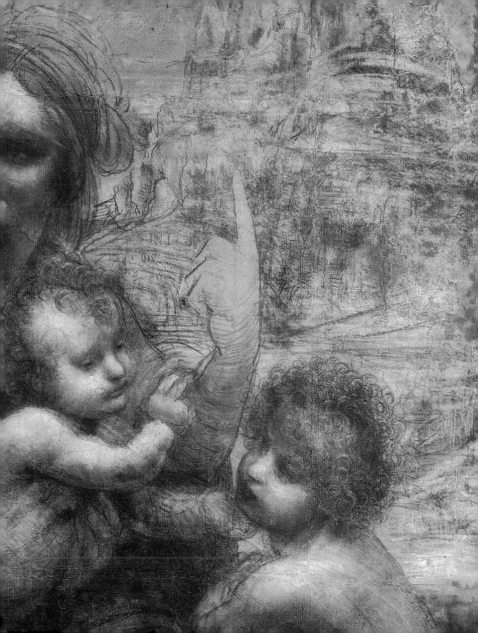

tions proposed by Leonardo to bring the mythological story to life were two: Leda standing, i.e. upright, and Leda kneeling.

As far as the first version is concerned, Leonardo's idea can be recognized in the panel now in the Galleria Borghese in Rome, which, along with the one formerly in the Spiridon Collection and now in the Uffizi, has to be considered only a copy. The variant of Leda on her knees, on the other hand, is known to us through two drawings, one in Rotterdam (Museum Boijmans van Beuningen) and the other at Chatsworth (collection of the duke of Devonshire). What needs to be pointed out here is that this model is once again derived from antiquity (the kneeling Leda is based on an ancient sculpture of "Crouching Venus") and was extremely popular in the 16th century.

Leonardo's interest in antiquity is again reflected in what is regarded, in the popular imagination, as the epitome of portraiture: the *Mona Lisa*. Or to give it its full title, the *Portrait of Monna Lisa del Giocondo*. The work was undoubtedly begun in Florence around 1503-04, but may not have been finished until 1510-15. The quality of this portrait in the old-fashioned half-length format is very high, a work without precedent in the genre owing to the powerful sense of psychological introspection conveyed by the sitter's expression, partly as a consequence of that sardonic smile.

The work was an immense success at the time, and its reputation continued to grow. By the 19th century it had become the most famous picture in the world: there is even a French expression *connu comme la Joconde*, "as well-known as the Mona Lisa". The theft of the painting on 21 August 1911 set the seal on that fame. The writer Guillaume Apollinaire and the artist Pablo Picasso came under suspicion, but the true culprit was Vincenzo Peruggia, an Italian who worked as a deco-

rator in the museum. The thief was eventually caught and the painting returned to its place in the Louvre on 4 January 1914.

I n 1506 Leonardo returned to Milan where, apart from a brief visit to Florence in the March of 1508, he remained to perform the function of official painter and engineer of the king of France, devoting himself to the study of questions of town-planning, hydrographic and geological problems and anatomy.

He left Milan for Rome on 24 September 1513 with his favourite pupils: Giovan Francesco Melzi, the aforementioned Salai, a certain Lorenzo and Fanfoja. He even had a studio set up especially for him in the Belvedere by Giuliano de' Medici, who was his patron and whom Leonardo also served as a military adviser. Here he devoted himself to scientific studies and the plan for the drainage of the Pontine marches. He came into contact with the new Medici pope, Leo X, the son of Lorenzo the Magnifico, and made a journey to Bologna in the retinue of Giuliano de' Medici and Leo X, who had gone there to meet the new king of France, Francis I. On the death of his patron Giuliano de' Medici, in March 1516, Leonardo accepted Francis I's invitation to go to France, to the castle of Cloux, near Amboise, where he in fact lived, loved and appreciated, until his death, holding the post of *premier peinctre et ingénieur et architecte du Roy, Meschanischien d'Estat*. In the Codex Atlanticus, folio 249 recto, Leonardo records being at Amboise, in the castle of Cloux, for the last time on 24 June 1518. He died on 2 May 1519, leaving, in a will dated 23 April 1519, all his manuscripts, drawings and instruments to his pupil Francesco Melzi; the paintings that were in his studio were inherited by Salai.

Works

1. *Madonna and Child
with a Pomegranate
(Dreyfus Madonna),
circa* 1469

2. *Madonna and Child*
(*Madonna with the Carnation*),
circa 1470

3. *Benois Madonna*,
circa 1478-82

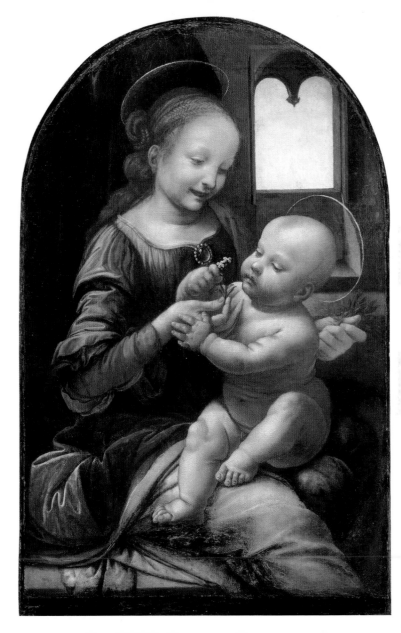

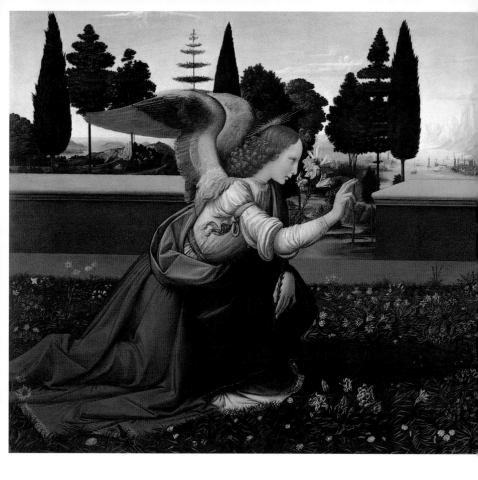

4. *The Annunciation,*
circa 1472-75

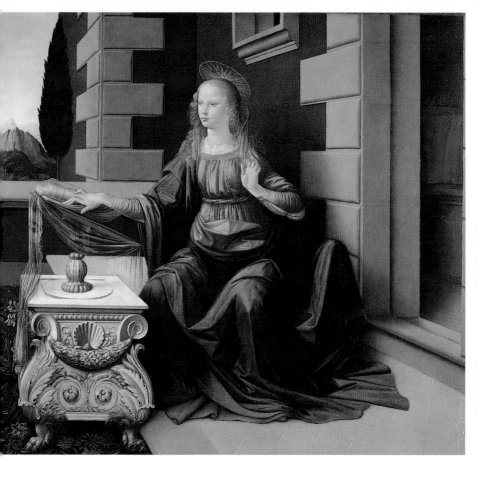

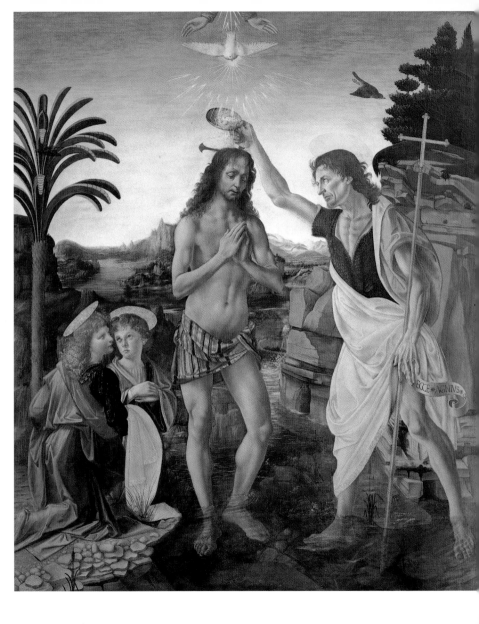

5-6. Andrea del Verrocchio,
Leonardo and others
Baptism of Christ (whole
and detail), *circa* 1475-78

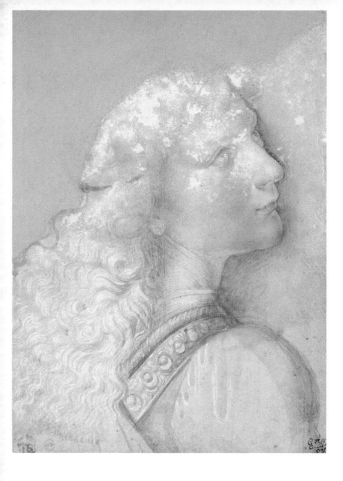

7. *Head of an Angel
in a Three-quarter View
from Behind, circa* 1473-75

8. Andrea del Verrocchio,
Leonardo and others
Baptism of Christ
(detail), *circa* 1475-78

44

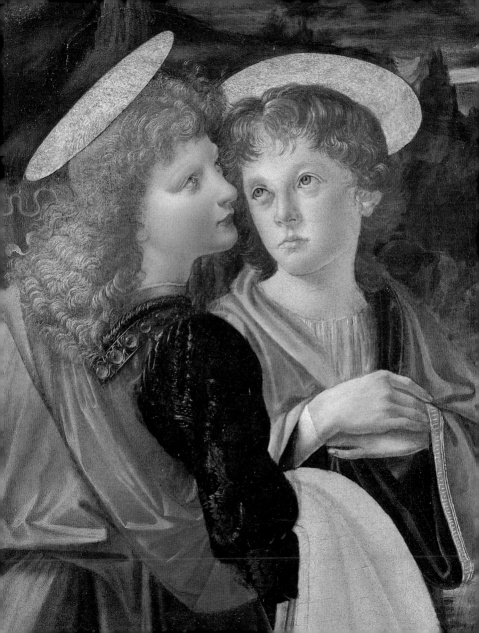

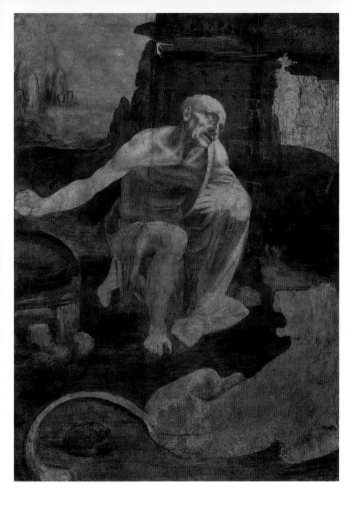

9. *Saint Jerome, circa* 1480

10. *Adoration of the Magi,*
1481-82

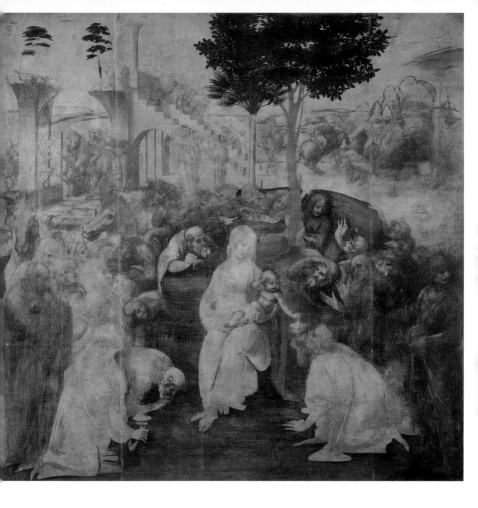

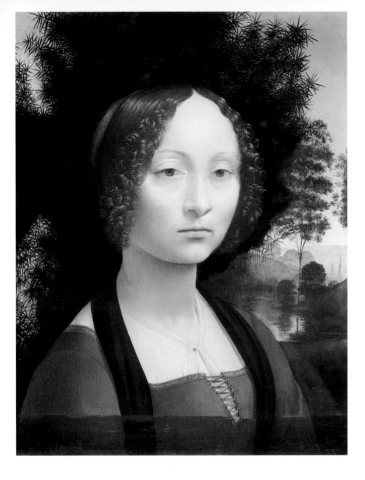

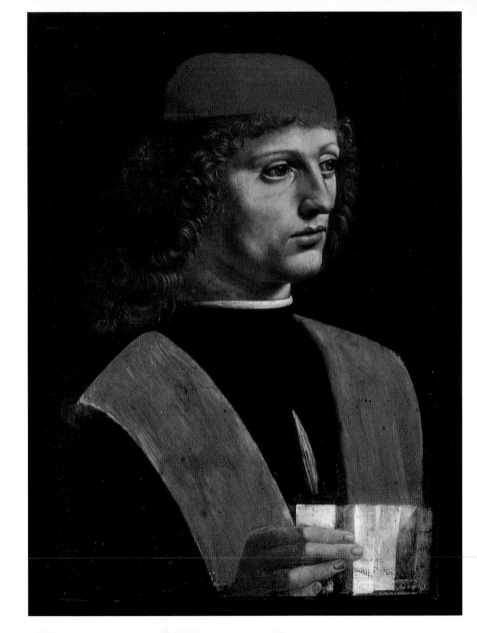

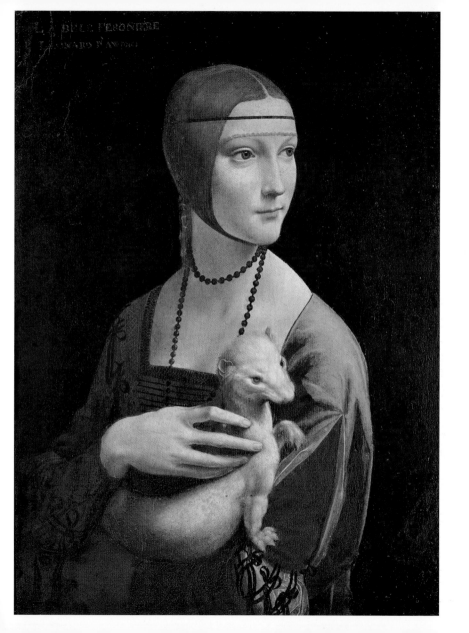

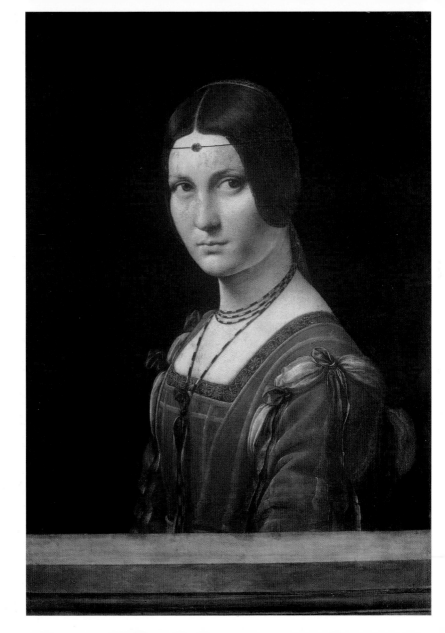

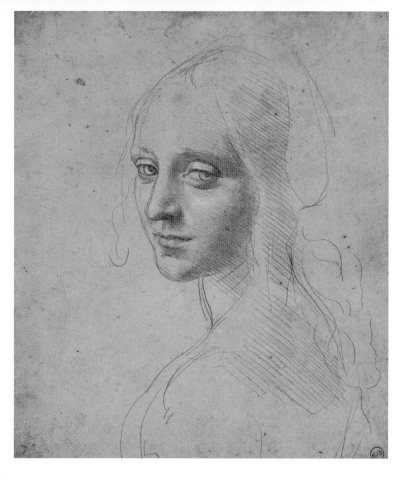

15. *Head and Shoulders
of a Young Woman
in a Three-quarter View
from Behind, circa* 1483-84

16. *Study for a Half-Length
Draped Male Figure
Turned to the Left, circa* 1490

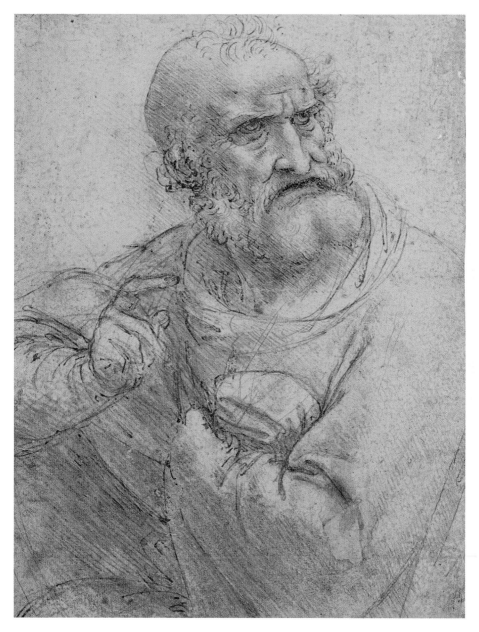

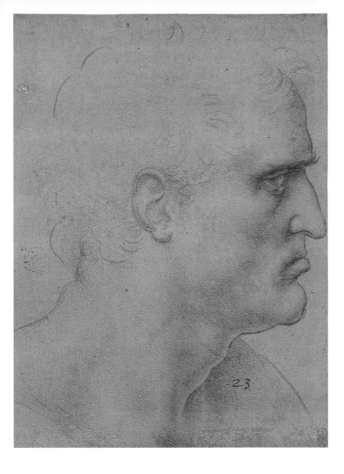

17. *Head of a Man in Profile Facing to the Left,* circa 1496-97

18. *Study for the Head and Shoulders of a Man in Profile Facing to the Right,* circa 1495-97

54

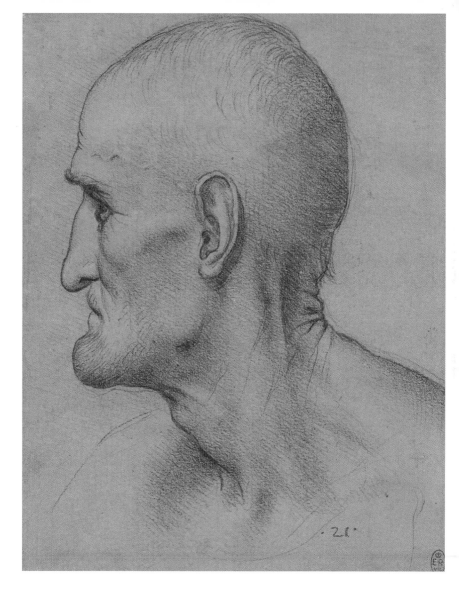

55

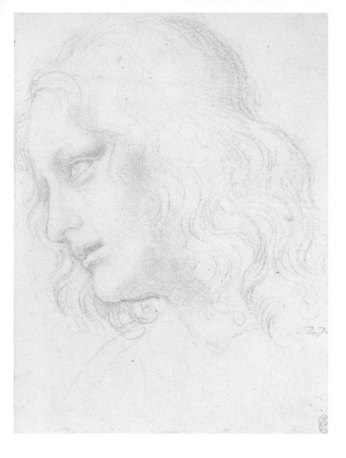

19. *Study for the Head
of a Young Man in Slightly
Three-Quarter View Facing
to the Right, circa* 1493-94

20. *Study for the Bust, Head
and Left Hand of a Man,
with Four Drawings of
Architecture, circa* 1492-94

56

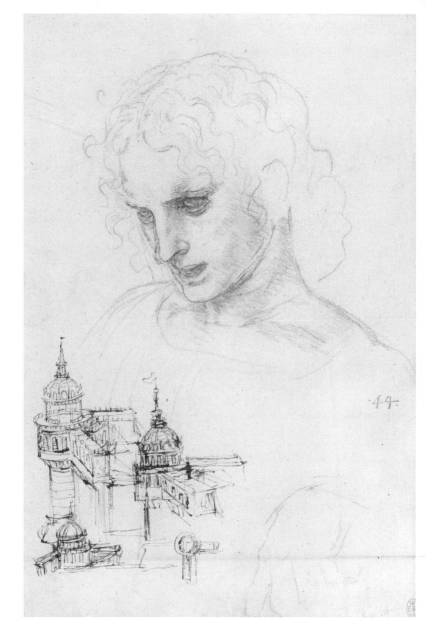

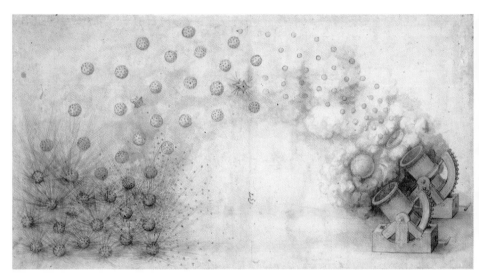

21. *Two Mortars with
Mechanism for Adjusting
Their Range, circa* 1483-85

22. *Vitruvian Man: Studies
of the Proportions of the
Human Body according
to Vitruvius, circa* 1490

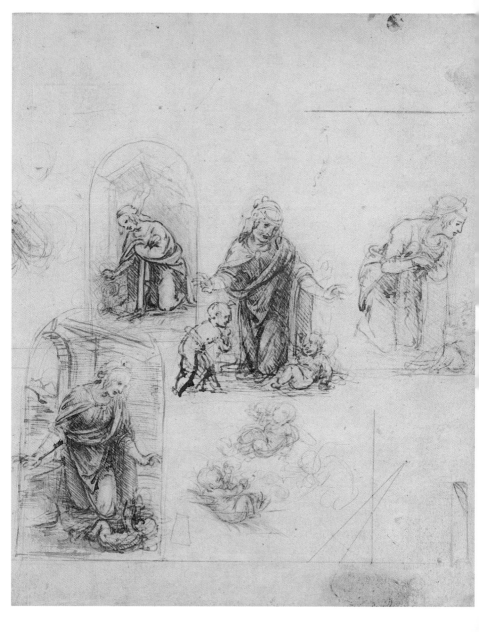

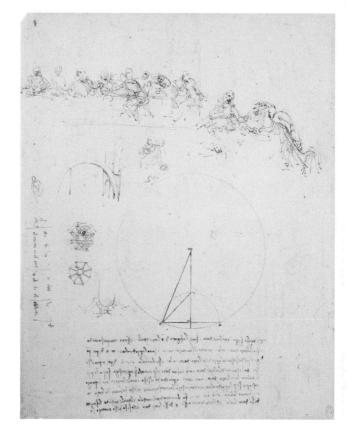

23. *Designs for a Nativity or Adoration of the Christ Child, circa* 1483-92

24. *Four Sketches for the Last Supper, with Drawing for the Construction of an Octagon, Four Architectural Sketches and Three Sequences of Numbers Commencing, at the Top, with the Number 32 and Ending, at the Bottom, with the Number 4, circa* 1490-92

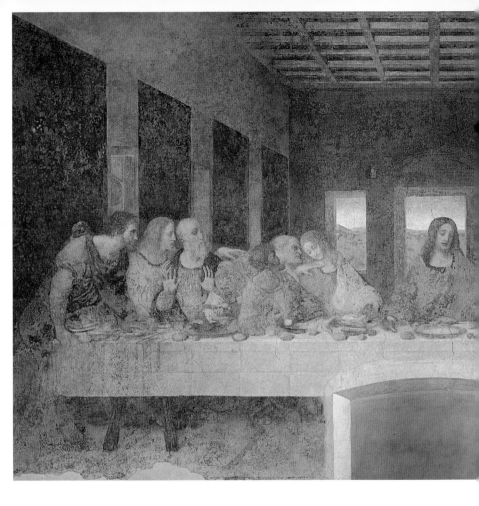

25-27. *Last Supper*
(whole and details
on following pages), 1494-97

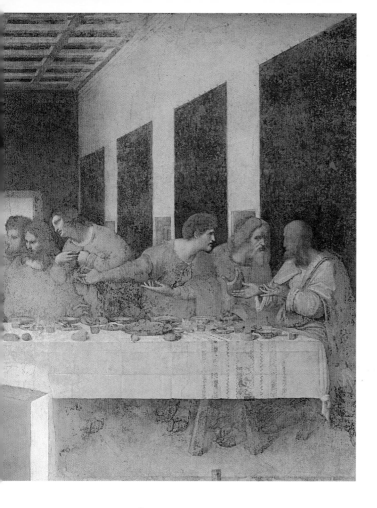

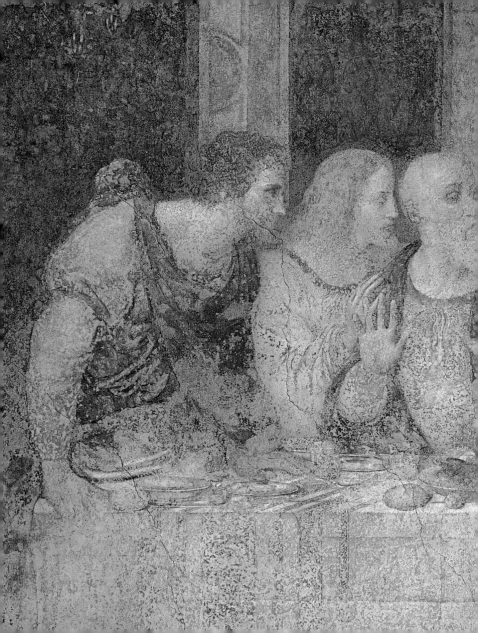

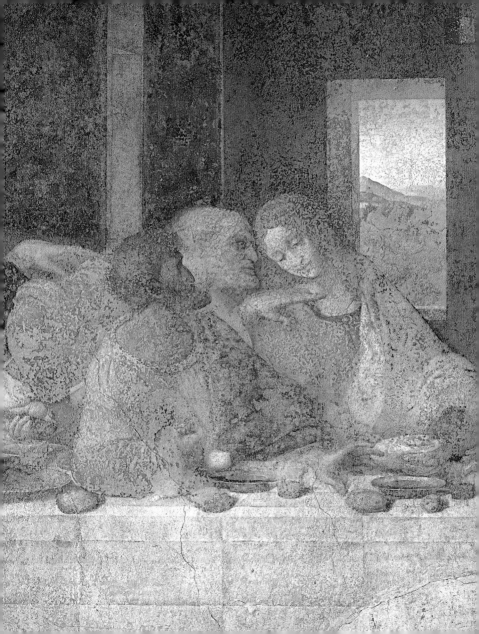

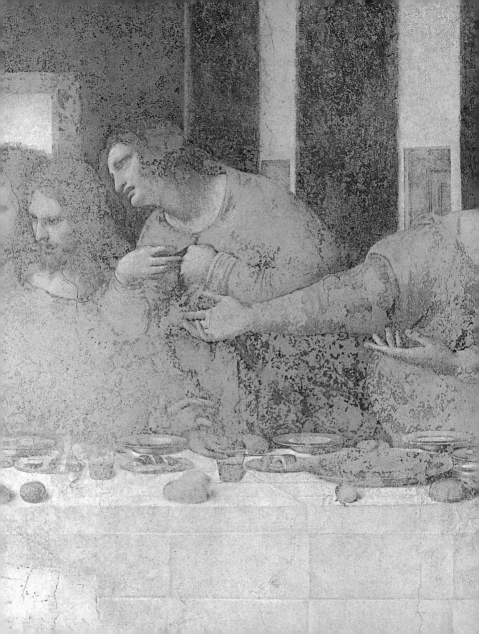

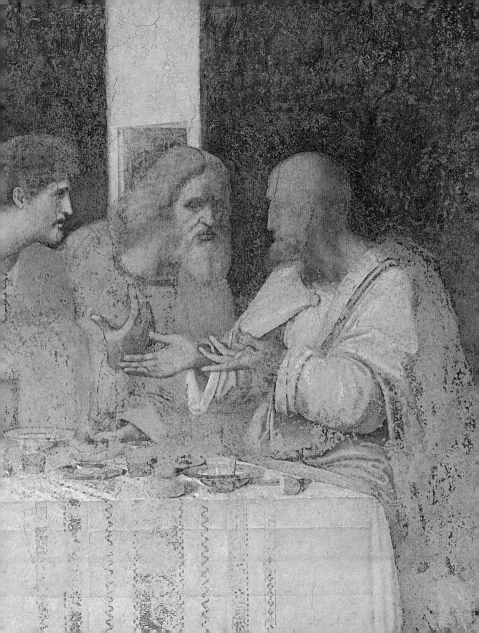

28-29. *Sala delle Asse*
(details), 1498

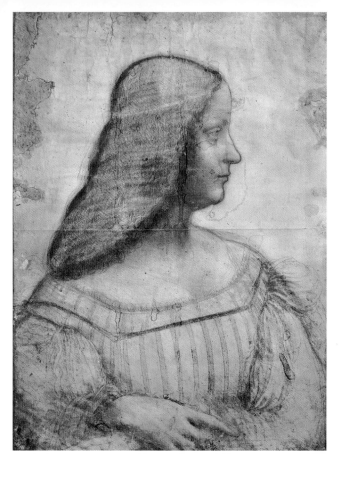

30. *Portrait of Isabella d'Este*, 1500

31. *Portrait of Monna Lisa del Giocondo (Mona Lisa)*, 1503-04 and 1510-15

Following pages
32. *The Virgin of the Rocks*, 1483-86

33. *The Virgin of the Rocks* (second version), 1495-1508

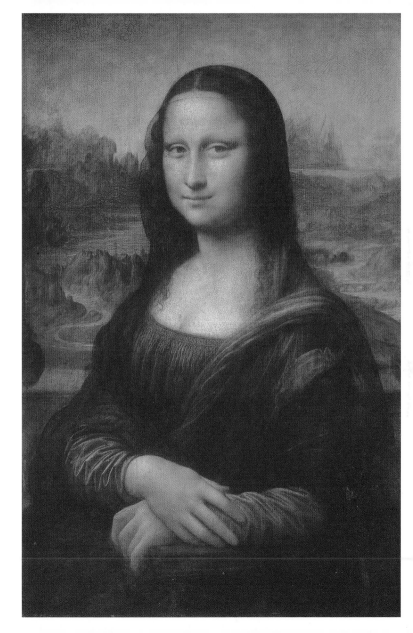

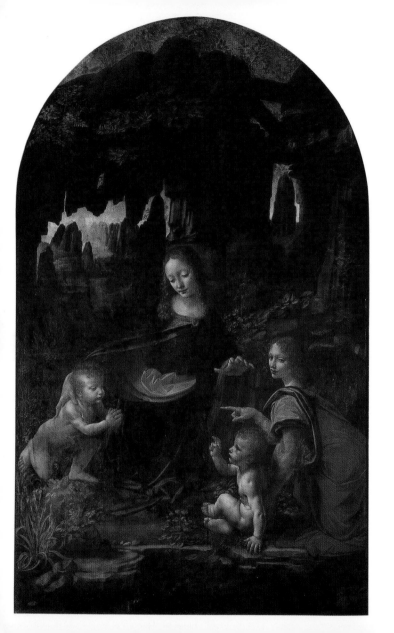

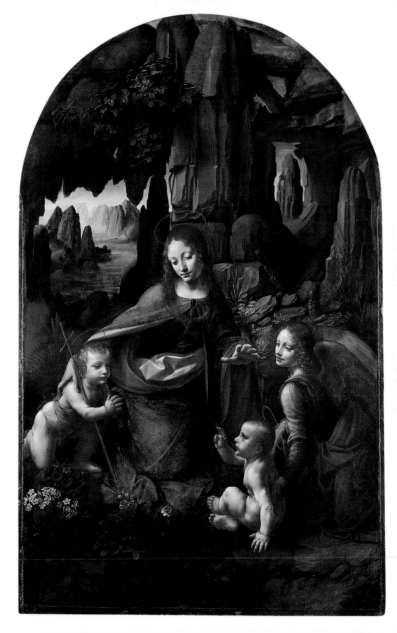

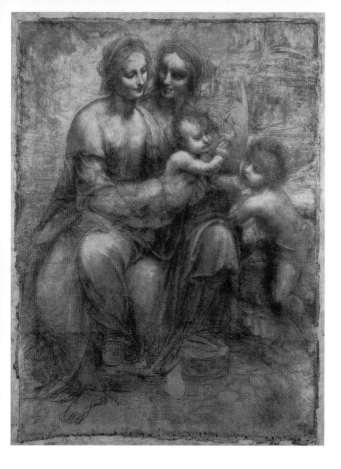

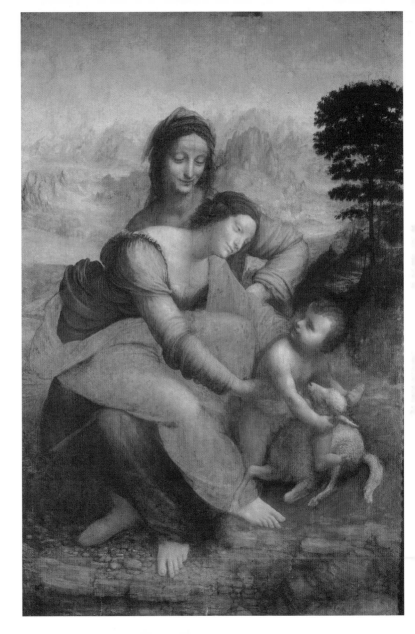

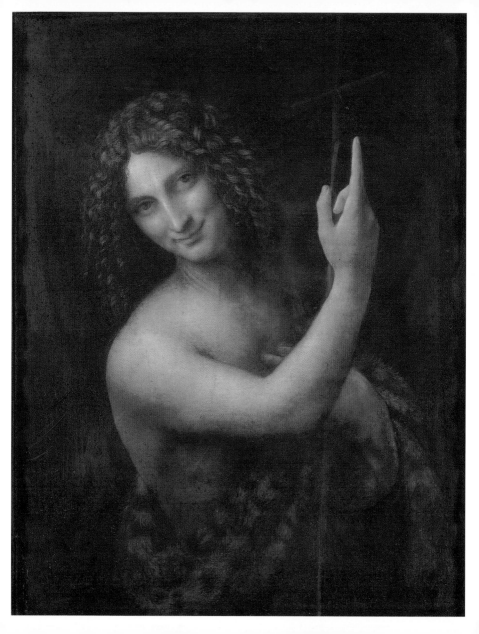

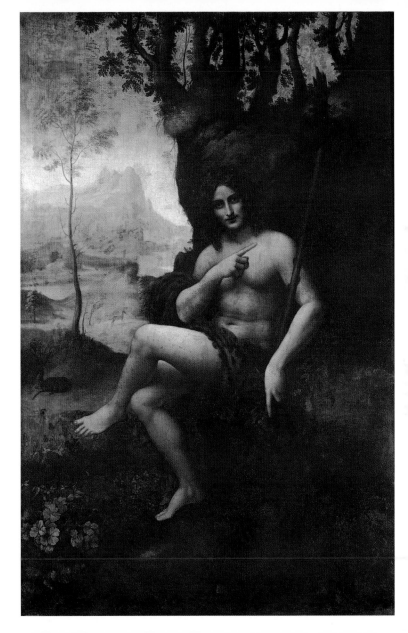

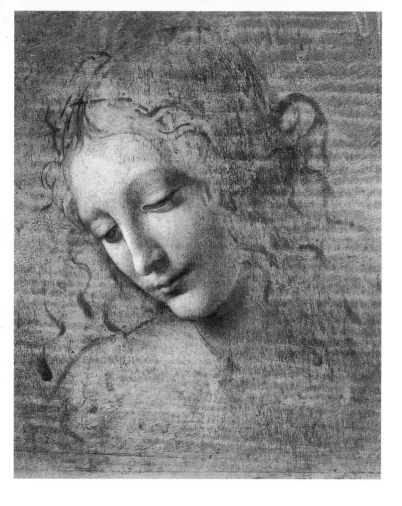

38. *Head of a Girl*
(*La Scapigliata*), *circa* 1508

39. *Leda* (after Leonardo),
circa 1515-20

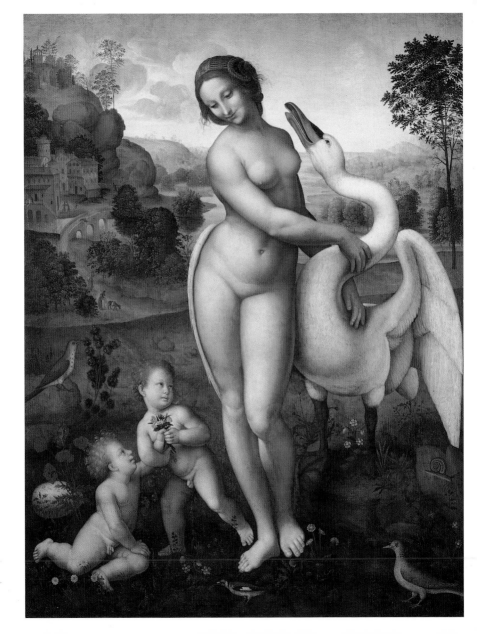

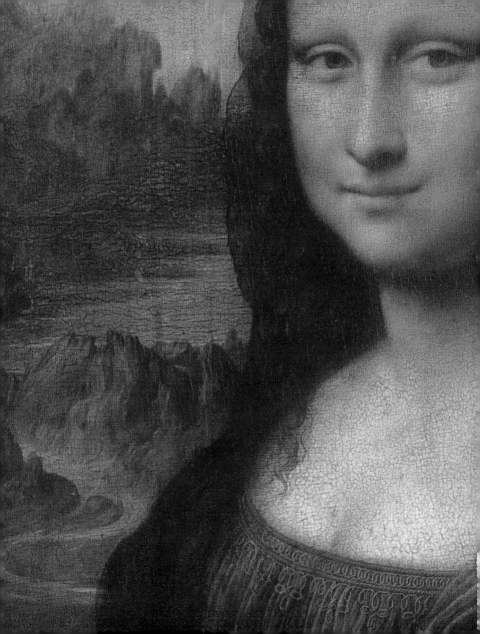

Appendix

Catalogue
of the Works

1. *Madonna and Child
with a Pomegranate* (*Dreyfus
Madonna*), *circa* 1469
Oil on wood, 15.7 x 12.8 cm
National Gallery of Art,
Washington, Kress Collection

2. *Madonna and Child*
(*Madonna with the Carnation*),
circa 1470
Oil on wood, 62 x 47.5 cm
Alte Pinakothek, Munich

3. *Benois Madonna*,
circa 1478-82
Oil on wood transferred
onto canvas, 48 x 31 cm
State Hermitage Museum,
St. Petersburg

4. *The Annunciation*,
circa 1472-75
Oil and tempera on wood,
98 x 217 cm
Galleria degli Uffizi, Florence

5-6. Andrea del Verrocchio,
Leonardo and others
Baptism of Christ (whole
and detail), *circa* 1475-78
Oil and tempera on wood,
177 x 151 cm
Galleria degli Uffizi, Florence

7. *Head of an Angel
in a Three-quarter View
from Behind*, *circa* 1473-75
Metalpoint, ochre watercolour
and white lead on pale ochre
prepared paper, 23.1 x 17.1 cm
Biblioteca Reale, Turin

8. Andrea del Verrocchio,
Leonardo and others
Baptism of Christ
(detail), *circa* 1475-78
Oil and tempera on wood,
177 x 151 cm
Galleria degli Uffizi, Florence

9. *Saint Jerome*, *circa* 1480
Tempera and oil on wood,
103 x 75 cm
Pinacoteca Vaticana,
Vatican City

10. *Adoration of the Magi*,
1481-82
Oil on wood, 246 x 243 cm
Galleria degli Uffizi,
Florence

11. *Ginevra de' Benci*,
circa 1474-76
Tempera and oil on wood,
38.8 x 36.7 cm
National Gallery of Art,
Washington

12. *Portrait of a Musician*
(*Franchino Gaffurio?*),
circa 1485
Oil on wood, 43 x 31 cm
Pinacoteca Ambrosiana, Milan

13. *Portrait of Cecilia
Gallerani* (*The Lady with
an Ermine*), 1488-90
Oil on wood, 54.8 x 40.3 cm
Czartoryski Museum, Cracow

14. *Portrait of a Lady*
(*La Belle Ferronnière*),
circa 1490-95
Oil on wood, 63 x 45 cm
Musée du Louvre, Paris

15. *Head and Shoulders
of a Young Woman
in a Three-quarter View
from Behind*, *circa* 1483-84
Metalpoint, with traces
of white lead, on pale ochre
prepared paper,
18.8 x 15.9 cm
Biblioteca Reale, Turin

16. *Study for a Half-Length
Draped Male Figure
Turned to the Left*, *circa* 1490
Silverpoint, pen and ink
on pale blue prepared paper,
14.6 x 11.3 cm
Graphische Sammlung
Albertina, Vienna

17. *Head of a Man in Profile
Facing to the Left*,
circa 1496-97
Red chalk on red prepared
paper, 19 x 14.6 cm
Royal Library, Windsor Castle

18. *Study for the Head
and Shoulders of a Man
in Profile Facing to the Right*,
circa 1495-97
Red chalk on red prepared
paper, 19 x 15.2 cm
Royal Library, Windsor Castle

19. *Study for the Head
of a Young Man in Slightly
Three-Quarter View Facing
to the Right*, *circa* 1493-94
Black chalk on white paper,
18.8 x 14.7 cm
Royal Library, Windsor Castle

20. *Study for the Bust, Head
and Left Hand of a Man,
with Four Drawings of
Architecture*, *circa* 1492-94
Red chalk, pen and ink,
25.1 x 17.1 cm
Royal Library, Windsor Castle

82

21. *Two Mortars with Mechanism for Adjusting Their Range*, *circa* 1483-85
Pen, sepia ink and bistre wash, 40.9 x 21.8 cm
Pinacoteca Ambrosiana, Milan

22. *Vitruvian Man: Studies of the Proportions of the Human Body according to Vitruvius*, *circa* 1490
Pen and ink with wash over metalpoint on paper, 34.4 x 24.5 cm
Gallerie dell'Accademia, Venice

23. *Designs for a Nativity or Adoration of the Christ Child*, *circa* 1483-92
Metalpoint partly reworked with pen and dark brown ink on pink prepared paper, 19.3 x 16.2 cm
Metropolitan Museum of Art, New York

24. *Four Sketches for the* Last Supper, *with Drawing for the Construction of an Octagon*, *Four Architectural Sketches and Three Sequences of Numbers Commencing, at the Top, with the Number 32 and Ending, at the Bottom, with the Number 4*, *circa* 1490-92
Pen and two types of ink on white paper, 26.6 x 21.4 cm
Royal Library, Windsor Castle

25-27. *Last Supper* (whole and details), 1494-97
Tempera and oil on two layers of chalky preparation laid over plaster, 460 x 880 cm
Refectory of Santa Maria delle Grazie, Milan

28-29. *Sala delle Asse* (details), 1498
Brush drawing on plaster, with 19th-century retouches
Castello Sforzesco, Milan

30. *Portrait of Isabella d'Este*, 1500
Black chalk, sanguine and yellow pastel on paper, 63 x 46 cm
Cabinet des Dessins, Musée du Louvre, Paris

31. *Portrait of Monna Lisa del Giocondo* (*Mona Lisa*), 1503-04 and 1510-15
Oil on wood, 77 x 53 cm
Musée du Louvre, Paris

32. *The Virgin with the Infant Saint John adoring the Infant Christ accompanied by an Angel* (*The Virgin of the Rocks*), 1483-86
Oil on wood, 199 x 122 cm
Musée du Louvre, Paris

33. *The Virgin with the Infant Saint John adoring the Infant Christ accompanied by an Angel* (*The Virgin of the Rocks*, second version), 1495-1508
Oil on wood, 189.5 x 120 cm
National Gallery, London

34. *The Virgin and Child with Saint Anne and Saint John the Baptist*, *circa* 1501(?)-05
Black chalk and touches of white chalk on brownish paper, 141.5 x 104.6 cm
National Gallery, London

35. *Virgin and Child with Saint Anne and a Lamb*, *circa* 1510-13
Oil on wood, 168 x 130 cm
Musée du Louvre, Paris

36. *Saint John the Baptist*, *circa* 1508-13
Oil on wood, 69 x 57 cm
Musée du Louvre, Paris

37. *Bacchus*, 1510-15 (?)
Tempera and oil on wood transferred onto canvas, 177 x 115 cm
Musée du Louvre, Paris

38. *Head of a Girl* (*La Scapigliata*), *circa* 1508
Umber, amber turned green and white lead on wood, 24.7 x 21 cm
Galleria Nazionale, Palazzo della Pilotta, Parma

39. *Leda* (after Leonardo), *circa* 1515-20
Egg tempera and oil on wood, 112 x 86 cm
Galleria Borghese, Rome

	Life of Leonardo	Historical events
1452	Leonardo is born at Vinci on 15 April, the natural son of the notary Piero di Antonio.	Piero della Francesca begins the cycle of the *Legend of the True Cross* in Arezzo.
1469	He is an apprentice in Verrocchio's workshop.	
1472	He enrols in the Compagnia di San Luca, the painters' guild.	
1476	He is accused of sodomy along with several other people. He is acquitted of the charge.	
1482	He moves to Milan.	
1483	Signs the contract for the *Virgin of the Rocks* with Evangelista and Ambrogio de' Predis.	Raphael is born in Urbino.
1488		Verrocchio dies in Venice. Bramante is in Pavia.
1489	He creates temporary decorations for the wedding of Gian Galeazzo Sforza and Isabella of Aragon.	
1491	Gian Giacomo Caprotti da Oreno called Salai enters Leonardo's service.	
1492	Marriage of Ludovico il Moro and Beatrice d'Este: Leonardo designs the costumes for the procession.	Lorenzo de' Medici dies. Discovery of the Americas.
1494	He begins work on the *Last Supper*.	Charles VIII of France, allied with Ludovico il Moro, leads his army into Italy.
1496	He starts to decorate some small rooms in the Castello Sforzesco. He is mentioned as the ducal engineer.	
1497	The *Last Supper* is probably finished by the end of the year.	

	Life of Leonardo	Historical events
1498	He completes the decoration of the Sala delle Asse in the Castello Sforzesco.	The *Pietà* in St. Peter's is commissioned from Michelangelo. Savonarola is burnt at the stake.
1500	He arrives in Venice, then returns to Florence.	
1502	He enters Cesare Borgia's service as "military architect and general engineer".	Bramante begins work on the Tempietto of San Pietro in Montorio and the courtyard of the Belvedere in Rome.
1503	According to Vasari he paints the *Mona Lisa* and *Leda*. The ruling council of Florence commissions the *Battle of Anghiari* from him.	
1509	Geological studies of the valleys of Lombardy.	Raphael starts the decoration of the Stanze.
1510	Anatomical studies at the University of Pavia.	
1512		Michelangelo finishes the ceiling of the Sistine.
1513	He stays in the Vatican under the protection of Giuliano de' Medici. He will devote his time to mathematical and scientific studies.	Julius II dies. He is succeeded by Giovanni de' Medici as Pope Leo X.
1514	Projects for the drainage of the Pontine marshes and for the port of Civitavecchia.	Bramante dies. Raphael takes his place in charge of the construction of St. Peter's.
1515		Raphael works on the cartoons for the tapestries in the Sistine Chapel.
1516	He moves to the summer palace of the French king Francis I at Amboise.	Charles of Habsburg becomes king of Spain.
1518	He takes part in the celebrations of the Dauphin's baptism and Lorenzo di Piero de' Medici's marriage to a niece of the king.	
1519	He draws up his last will and testament on 23 April. The executor is his friend, the painter Francesco Melzi. He dies on May 2.	Charles V of Habsburg is elected ruler of the Holy Roman Empire; there is open conflict between France and the empire.

M. Bandello
Novelle, 1497

[Leonardo] was in the habit of going there early in the morning, and I have seen him do so many a time, and climbing the scaffolding, for the *Last Supper* is set quite high above the ground; and he would stay there painting from sunrise till nightfall, never putting down the brush and forgetting to eat or drink. Then two, three or four days would go by without his touching the work, and yet he would still spend one or two hours a day just looking at the figures he had painted and criticising them to himself. I have also seen him, when the whim took him, leave the Corte Vecchia where he was working on that wonderful clay horse, at midday, when the sun was at its height, and come straight to Santa Maria delle Grazie, and clamber onto the scaffolding, pick up the brush, add one or two strokes to one of those figures and then leave at once, going off somewhere else.

C. d'Amboise
Letter from Milan to the rectors of Florence, 1506

The excellent works of art that your fellow citizen Magister Leonardo da Vinci has left in Italy, and especially in this city [Milan], have led all those who have seen them to love him greatly, even if they have never seen him. And we must admit to be among the number of those who loved him before we ever met him. But since we have had dealings with him here, and direct experience of his virtues, we see truly that his name, celebrated for painting, is obscure in comparison with what deserves to be praised for the other things that are great virtues in him (…).

B. Castiglione
Il Cortegiano, 1528

Another of the greatest painters in this world [Leonardo] looks down on this art in which he is unequalled, and has set about learning philosophy, in which he has such strange ideas and new fancies, that he, with all his talent, would not know how to paint them.

Anonimo Gaddiano
Draft of the *Libro di Antonio Billi*, 1537-42

His genius was so rare and universal that it can be said that nature worked a miracle on his behalf: not only did it grant him great beauty of the body, but chose to make him the master of many rare talents. Highly skilled in mathematics and in perspective no less, he worked in sculpture, and in drawing greatly surpassed all others. He had very beautiful ideas, but did not paint many things, for he never said to himself that he was satisfied, and so his works are very few. He was a most eloquent speaker and an exceptional player of the lyre, and was the teacher of that instrument to Atalante Migliorotti. He tended and took delight in medicinal herbs and was an expert in pumping and plays of water, and other caprices, and was never content to rest on his laurels, but was always using his ingenuity to make new things.

S. Serlio
Il secondo libro di perspectiva, 1551

(…) In truth theory lies in the intellect, but practice consists in using the hands, and so the highly knowledgeable Leonardo Vinci was

never content with what he did, and took very few works to perfection, often saying that the reason was this: that his hand could not keep up with his mind.

L. Dolce

Dialogo della pittura, 1557
Leonardo was equal in all things to Michelangelo, but had such a high intelligence that he was never content with what he did.

G. Vasari

Vite de' più eccellenti architetti, scultori e pittori (*Lives of the Most Eminent Painters, Sculptors, and Architets*), 1568
Marvellous and divine, indeed, was Lionardo (…) Nature favoured him so greatly that wherever he turned his heart, his mind, and his thoughts he showed such sublimity in the things he did that no-one has ever equalled him in giving them perfection of vividness, liveliness, excellence, beauty and grace.
It is clear that Leonardo, through his comprehension of art, began many things and never finished one of them, since it seemed to him that the hand was not able to attain to the perfection of art in carrying out the things which he imagined (…).
So marvellous was [Lionardo's] mind that, desiring to throw his things into greater relief, he endeavoured to obtain greater depths of shadow, and sought the deepest blacks in order to render the light clearer by contrast. He succeeded so well that his scenes looked more like representations of the night, there being no bright light, than ones clearly defined by daylight, though all was done with the idea of throwing things into greater relief and to find the end and perfection of art. (…) To the art of painting he added a type of darkness to the style of colouring in oils whereby the moderns have imparted great vigour and relief to their figures (…).

G.P. Lomazzo

Idea del Tempio della pittura, 1590
Vinci's impulses are those of nobility of the soul, of facility, of clarity of imagination, of the nature of knowledge, thought and action, of mature counsel, combined with the beauty of faces, of justice, of reason, of judgement, of the separation of unjust things from the just, of the brightness of the light, of the depth of the shadows, of ignorance, of the profound glory of the truth and of charity queen of all the virtues. Thus he appeared to tremble the whole time when he set himself to paint, and yet he never completed any work he had begun, having so high a regard for the greatness of art that he discovered faults in things that to others seemed miracles. In his use of light Leonardo shows that he has always taken care not to make it too bright, to keep it for the best place, and has sought to make the darkness very intense, to find its extremes. Such art has he attained in faces and bodies, that he has made them truly marvellous, the equal of anything nature can do. And in this he has been superior to all, so that in a word we can say that Leonardo's light of is divine.

A. Félibien

Entretiens sur les Vies et les Ouvrages des plus excellents Peintres Anciens et Modernes, 1666
The great ideas that he had of the perfection and beauty of the things have meant that in his desire to take his works beyond the extreme limit of the possibilities of art, Leonardo traced figures that are not at all natural. In fact he strongly emphasized the

outlines, lingered over retouching the smallest things and put too much black in the shadows. But he did not fail to display his abilities in drawing and in the handling of light, through which he was able to give all bodies a relief that deceives the eye (…).

J.P. Grosley

Nouveaux Mémoires sur l'Italie et les italiens par deux gentilshommes suédois, 1764
(…) This work [the *Last Supper*] seemed beautiful to me, but of a masculine, firm and severe beauty for which there is little appreciation in France.

W. Goethe

Italienische Reise, 1816-1829
(…) Although a universal genius, Leonardo revealed his greatness above all as a painter. Regularly and perfectly formed, he appeared, in comparison with common people, an ideal specimen of humanity. Just as clarity and keenness of the eye are related most directly to the intellect, clarity and intelligence were characteristics of the artist. He never yielded to the latest impulse of his own original and incomparable talent and, curbing any spontaneous and incidental urge, wanted everything he did to be considered over and over again. From his research into pure proportions to the extraordinary and contradictory figures of his most hybrid monsters, everything had to appear natural and rational.

H. Beyle (Stendhal)

Histoire de la peinture en Italie, 1817
It had that melancholic and delicate colouring, rich in shadows, without splendour in the brilliant colours, that triumphed in the chiaroscuros and that, if it had not existed, would have had to be invented for such a subject [the *Last Supper*].

J. Burckhardt

Der Cicerone, 1855
[He] is more realistic than his predecessors who acknowledge the supremacy of reality, only to become free and sublime again in a way that, over the centuries, few artists have known how to be.

C. Baudelaire

Les fleurs du mal, 1857
Da Vinci, dusky mirror and profound, / Where angels, smiling mystery, appear, /
Shaded by pines and glaciers, that surround / And seem to shut their country in the rear.

E. Delacroix

Journal, 1857-1863
Almost contemporary with Ghirlandaio, a fellow student of Lorenzo di Credi and Perugino he all of a sudden left behind the traditional painting of the 15th century; and arrived without errors, without failings, without exaggerations, and almost at one fell swoop, at that judicious and masterly naturalism, equally distant from slavish imitation and from an empty and chimerical ideal. What a strange thing! The most methodical of men, the one who among the masters of that time was most concerned with methods of execution, who taught them with such precision that the works of his best pupils are constantly being confused with his, this man, whose "manner" is so characteristic, has no "rhetoric". Always attentive to nature, examining it relentlessly, he never imitates himself; the most erudite of the masters is also the most ingenuous, and neither of his two rivals, Michelangelo and Raphael, is as worthy of such praise.

L. Venturi
La critica e l'arte di Leonardo da Vinci, 1919
What Leonardo suggests when he draws, he realizes when he paints: air, light, movement. It is a function that for centuries was required of colour, and Leonardo has no colour.
In Florence he found a vivid colour, suited to rendering a solid surface precious. He rejected it because he didn't care about solid surfaces. His eye was too drawn to the sweeping horizons of wide valleys, interrupted by hills, bounded by mountains. What could a solid surface signify for a distant vision of broad horizons? It was well suited to defining a human body viewed from close-up.
But Leonardo's eye wanted to see even the human figure from faraway. From close by everything seems still; the perpetual fluctuation of the atmosphere makes every distant thing light, as if hovering in flight. And the peace of the evening, when dusk envelops souls and things, imparts a slow, uninterrupted vibration to the horizon. Shadows, atmosphere, physical movement of every molecule of the universe, spiritual vibration lost in dream, distant vagueness of masses that penetrate one another; all this he turned into the human figure. Form without form. And colour without colour. Chromatic vision of form, formal realization of colour.

O. Sirén
Léonard de Vinci, 1928
There can be no doubt that, especially at the beginning of his career, the sculptor in him vied with the painter. He was Florentine to the core, though alerter, suppler and more intelligent than any of his predecessors. Later on he dealt with problems in painting as he investigated scientific ones; which explains the presence, in his art, of new tendencies

and elements unknown in his contemporaries. The shift from sharply defined details and contours towards inclusiveness, towards melting chiaroscuro and picturesque sfumato, epitomizes a general trend in Renaissance painting; but what around Leonardo took two or three generations to accomplish, ripened in him in the space of twenty or thirty years. No artist has been quicker to assimilate the forms of expression inherited from the past and to create new ones; no-one has been more capable than he of making form the living vehicle of his idea of art. Another aspect of his Florentine energy is found in his determination to grasp the salient points and characteristic traits in everything: the keynote, as it were, of Leonardo's art is essentially Florentine; but he would be able to find harmonies of a richness unknown in the art of his homeland before him.

A. Venturi
"L'arte di Leonardo", in *Enciclopedia italiana*, XX, 1934
In the Renaissance, that unifier of human activities, art signified science, art signified the truth of life. Here emerged the figure and the greatness of Leonardo, who took on himself the epic effort of Italian art to conquer the universal: a man who balanced within himself the wavering sensibility of the artist with the profound reasoning of the scientist, a poet and master.

C. de Tolnay
"Remarques sur la Joconde", in *Revue des Arts*, 1951
In the *Mona Lisa*, the individual – a sort of miraculous creation of nature – represents at the same time the species: the portrait, having overcome social limits, takes on a

89

universal value. Leonardo worked on this picture both as a researcher and thinker and as a painter and poet; and yet the philosophical and scientific side was not followed up. But the formal aspect – the new layout, the nobility of the pose, and the dignity of the model that derived from it – had a decisive effect on the Florentine portrait of the following two decades, the classical portrait (…). With the *Mona Lisa* Leonardo created a new formula, more monumental and at the same time more animated, more concrete, and yet more poetical too than that of his predecessors. Before him there was no sense of mystery in portraits; artists did no more than represent external forms without a soul; or, when they did set out to characterize the soul, they sought to convey it to the observer through gestures, symbolic objects and inscriptions. Only from the *Mona Lisa* does an enigma emanate: the soul is present but inaccessible. This poetry of mystery is deepened by the intimate unity of the figure with the landscape in the background (…).

E. Cecchi

"Considerazioni su Leonardo", in *Lo smeraldo*, 1952
(…) The only Tuscan artist, in command of great creative powers, capable of taking, as he in fact did, a road all of his own (…) avoiding the violent course of the extreme linear style. And from him arose a manner of painting of unrivalled intensity, where the rugged chiaroscuro and luminism of Masaccio has been brilliantly transformed into an abundance of plastic expression that, if we must once again turn to the memory of Greece, can only be compared with the mysterious and sublime grace of Praxitelian sculpture.

R. Longhi

"Difficoltà di Leonardo", in *Paragone*, 1952
(…) The clue to understanding the mental contradictions that arose in him [Leonardo] subsequently may lie in investigating how, from the multifaceted and rapid nature of the Florentine sketch of the *Adoration of the Magi*, he could get himself confined within the "magic pyramid" of the *Virgin of the Rocks* or the legalistic scanning of the scene by groups of three in the Milanese *Last Supper*. It is certainly the old myth of perspective and proportion that underpins the mystery; it is a prelude to Raphael's *Stanze* ten years ahead of their time; but with that charge, at bottom, of explosive vitality, the need for a different rule remains hard to understand. Similarly, it is necessary to wonder about the significance of the emergence of the special problem of "light and shade". It is frivolous even to suppose that it is a question of colour or, perhaps, impressions. Leonardo's anti-impressionistic program was made fairly clear when he recommended "never paint leaves transparent to the sun, because they are confused".
And how could it have been otherwise for someone who believed that the highest quality in painting was "to show relief on a flat surface"? Suited to the purpose was the privileged and eminently Florentine tradition of "chiaroscuro" abstracted into "universal light"; and Leonardo had no desire to renounce it. So he thought of clouding it, softening it, toning it down; an adaptation which, on that basis, would never have been able to find a form of its own, but merely hint allusively at a desire for sentimental, poetic escape, into a twilit, crepuscular world, into a "brownish air", into that "certain darkness" of which Vasari speaks; and remained that way,

in ambiguous contrast with his prime gift for vital lucidity. and even with his rites of classical equilibrium. It was then that his thoughts and his figures appeared, veiled and hazy, sometimes even a bit macabre, out of the caves of the Lombard foothills of the Alps already explored by Leonardo the speleologist; and so it will not seem at all strange that precisely this last contrivance should have been appreciated, more than all the rest, by the Romanticism and Decadentism of the last century, much more interested in mysteries than in clear explanations.

L.H. Heydenreich

"Leonardo da Vinci", in *Enciclopedia universale dell'arte*, VIII, 1958
Leonardo's drawings of the Deluge are symbols of (…) primordial forces caught at the moment of their manifestation in their extreme, final activity: when they dismember what they themselves generated, formed and set in motion, but answering, even in this destructive action, to the need for even the end of the world to take place in an orderly and harmonious fashion. The extreme conclusions of Leonardo the scientist take form in artistic creations. In this the magnificent unity and inseparability of his scientific and artistic ideas is revealed once again (…). The extent to which he was clearly aware of all this is apparent from his own words: "Nature is full of infinite causes that have never occurred in experience". To the end of his life, he believed in the existence of a supernatural harmony which is operative in all forms and forces, in all places and at all times, and which appears even in the seeming chaos of the end of the world. He tried to seek out this harmony in all

phenomena which his mind apprehended, and attempted to present it in his works through the medium of his art, which was the instrument of his research and science.

M. Brion

Léonard de Vinci, 1959
The brothers of San Francesco Grande found themselves presented with a picture [the *Virgin of the Rocks*] that did not look anything like what they had wanted and requested and that, in addition, caused unease and surprise in the members of the congregation who saw such a mysterious composition on their most venerated altar. The prophets, who were to have had the same role in the picture as the saints and doctors of the Church in the *Sforza Altarpiece* [painted by an anonymous Lombard artist, now in Brera], had vanished, as had the angels playing musical instruments that were supposed to surround the Madonna: the ones that the master had left to the brush of Ambrogio de' Predis were confined to the wings of the altarpiece. For Leonardo knew well that the secret music with which the whole of this painting resounds could not be heard if the listener's eye were to be distracted by some painted instrument. So he deliberately rejected those fine groups of musician angels that had been ordered from him and that Piero della Francesca and Bramantino had painted with such inspiration. If they had been present, the observer would have thought of the music of the heavenly ranks, distracted from that of the painting, which is not to be heard but just to be felt inside us. For the music of the *Virgin of the Rocks* to rise in its elementary and celestial chords, it is necessary for the instruments to be invisible, as it is the music of the plants, the water and the wind between the spurs of the

rocks, the gestures and the smiles, which no flute or lyre or lute would have been able to express. The harmony that is sensed here is the song of the earth, the breathing of the elements, the message of that *Erdgeist* ("spirit") which appeared to the elderly Faust one day and terrified him, but which was familiar to the young Leonardo, who was well aware that the soul of the world and that of the artist are one and the same thing.

G. Castelfranco
Studi vinciani, 1966
The true moment of birth of Leonardo's landscape painting is the background of the *Annunciation* in the Uffizi (…) divided up between tree and tree, between the wing of the angel and the low wall, although continuing in closely knit topographical unity and uniformity of illumination. It is the depiction of a road that descends on the left between hills and rocks towards the valley, while on the right two cities with fortresses and towers face one another across the broad estuary, with a weir and a lighthouse in the middle and mountains of living rock closing off the gulf in the distance. It looks nothing like any Tuscan port, but is a utopian and yet logical landscape (just as the description of the capital of Thomas More's Utopia is extremely logical); while clearly inspired by examples of Flemish painting, there is no hint of Northern European architecture to be seen. Unlike the Flemish-influenced Florentine works of the previous decade, however, the landscape reflects light in a perfect logic of illumination and an extreme correctness and richness of tones. Just look at the rocks lit up by the sun on the left, or the mountains to the right of the city. On the other hand we must also note that in

these more distant and higher and more alpine mountains there is a certain simplification and, I am tempted to say, a certain conventionality in comparison with Leonardo's later landscapes (…). In the background of the *Mona Lisa* stand enormous and complicated jutting rocks, serving as a backdrop to the woman's head, so that it is no longer set against the sky in the Tuscan manner, but against the distant bluish landscape; it is the winding road, the river on the right and the bridge and above all the two mountain lakes. Readings, direct experience, scientific principles, pictorial fantasy: this type of mountain so worn-down at the bottom is fully in keeping with Leonardo's Neptunian ideas, for he believed that mountains are the product of erosion by water, which over the vastness of time eats away at their roots and makes them fall "little by little into the rivers". Already in the *Virgin of the Rocks* Leonardo's landscape hinges on elements that attempt to lay as bare as possible the process of formation of mountains, i.e. stratification and erosion.

C. Pedretti
Leonardo, 1979
It can be said that Leonardo was unique and inimitable precisely because he had imposed on himself a strict professional discipline that consisted of study and practice at one and the same time and that, as such, could not subordinate his knowledge of the physical world to the expression of his own emotions. When he speaks of himself as a painter it is as if to take note of a mistake to be avoided, so that his precepts are not so much advice to others as warnings to himself. Thus, when remarking on how the pupil grows and shrinks in response to the intensity of the

light to which it is exposed (and the observation dates from the years of his portraits at the Sforza court), he admits: "and this very thing has already deceived me in painting an eye, and from that I learnt it".

P. C. Marani
Leonardo. Catalogo completo dei dipinti, 1989
Leonardo had in fact greatly accelerated the process of acknowledging the intellectual value of artistic work, and legitimizing it as a theoretical activity. The case of his anatomical studies is telling in this regard: initially, during the Florentine period, he had applied himself to the study of anatomy in a wholly pragmatic way, intended to meet the needs of artistic representation, as was in fact traditional for Florentine artists, but then the further he went in this study the more he became fascinated by the "human machine", seeking to uncover the laws by which it operated and eventually leading him to raise questions about the nature of the soul. Thus many of the components of the "machinery of the world", at first disclosed to his eyes simply as the subject of artistic representation, came to be investigated by him out of innate curiosity, for he gradually realized that everything was worthy of understanding, of being studied in its formation and its modification, and helped to explain other correlated facts and other phenomena in a variety of fields. So the "imitation" of nature increasingly became a cognitive exercise and then, at the moment in which it was applied to painting, a moment of creative synthesis. In Leonardo's mind "imitating", it is worth repeating, amounted to "re-creating", as if to underline his desire not to "reproduce" but to "produce" just as nature itself produces.

A. Natali
Leonardo. Il giardino di delizie, 2002
So let us take another look at the *Annunciation* (…); and look at it, following its restoration, with eyes that now see clearly what before had been rendered indistinct to say the least by a dark coating; but above all let us look at it carefully, and with a mind ready to follow the traces of a theological symbology, which might also lead to useful hypotheses on the strictly historical plane. Now, that view of the landscape, fantastic and at the same time realistic, which appears at the centre of the composition and which, before, could at the most be seen as a sort of window opening onto infinity (and in the end not even all that original in its elements of nature), expressly demands a reflection (…). It should be clear to all that between the trees (cypresses, firs and elms: species that, incidentally, evoke the sanctuary of the Lord (…), and here the sanctuary is the virginal womb of the Madonna) there are a high mountain and a city by the sea: a vision so lucid that it even becomes the protagonist of the picture. The screen of trees is interrupted there, right in the middle of the scene, so that the vision is able to emerge in all its force: evoking a mysterious presence, which is necessarily important if it equals and perhaps even overshadows not just the presence of the announcing angel, but even that of the Virgin Mary herself.